The Lewis Chessmen
James Robinson

THE BRITISH MUSEUM PRESS

For Sarah and Lydia

Copyright © 2004 The Trustees
of The British Museum

James Robinson has asserted his
moral right to be identified as the
author of this work

First published in 2004 by
The British Museum Press
A division of The British Museum
Company Ltd
38 Russell Square,
London WC1B 3QQ

Reprinted 2005, 2007, 2009
2010
A catalogue record for this book is
available from the British Library

ISBN: 978-0-7141-5023-9

Designed by Esterson Associates
Typeset in Miller and
Akzidenz-Grotesque
Printed and bound in China by
C&C Offset Printing Co., Ltd.

Map by ML Design
All photographs © The Trustees
of The British Museum, courtesy
of the Department of Photography
and Imaging, except for the
followings figures: 1 Image courtesy
C. Palmer, www.buyimage.co.uk,
01279 757917; 3 National Museums
of Scotland; 22 The Walters Art
Museum, Baltimore (71.145);
24 Fratelli Manzotti, Piacenza;
28 Photograph Lene Sterns Jensen.

Acknowledgements
Joanna Bowring, Laura Brockbank,
Sue Byrne, David Caldwell,
Caroline Cartwright, John Cherry,
Nigel Cox, Irving Finkel, Ian
Freestone, James Graham-
Campbell, M.S. Humphrey, Andrew
Kitchener, Griff Mann, Andrew
Middleton, Saul Peckham, Else
Roesdahl, Pam Smith, Sovati Smith,
C.P. Stapleton, Neil Stratford,
Beatriz Waters, Leslie Webster,
Gareth Williams.

Contents

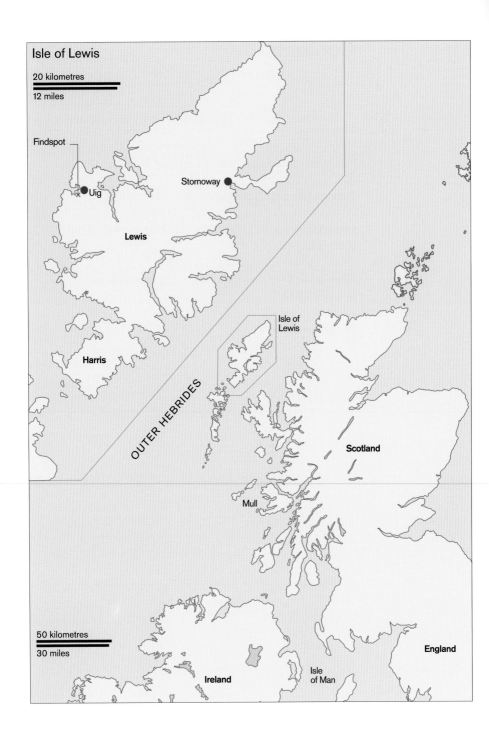

Isle of Lewis

20 kilometres

12 miles

Findspot

Uig
x

Stornoway

Lewis

Harris

OUTER HEBRIDES

Isle of
Lewis

Scotland

Mull

50 kilometres

30 miles

England

Ireland

Isle
of Man

Discovery, skulduggery and dispersal

The story of the Lewis chessmen's discovery is full of mystery and intrigue. The find was made in 1831 on the Isle of Lewis in the Outer Hebrides, but its precise circumstances may never be known, and may even have been deliberately obscured.

The Hebrides consist of more than 500 islands which extend over almost 250 miles off the west coast of Scotland. Lewis is the largest of the islands and the Butt of Lewis forms the northernmost part of the Hebrides. Its serrated coastline of coves and harbours along with its network of lochs means that water is never far away from any single point on land. The water affects the climate, the quality of light and the character of the people, as it has frequently determined the course of their history and livelihood. It is a wild and remote terrain which conspires to keep its secrets.

As early as 1833 the Scottish academic David Laing (1793–1878) remarked to the Fellows of the Society of Antiquaries of Scotland:

> It is evident, that to serve some purpose, contradictory statements were circulated by the persons who discovered or who afterwards obtained possession of these Chess-men, regarding the place where the discovery was actually made.

According to the earliest accounts, the findspot appears to have been Uig Bay (fig. 1). The chessmen were found with fourteen tablemen gaming pieces (see pp. 54–5) and an intricately engraved belt buckle. Each item was carefully crafted from walrus tusk, with a few of the chesspieces probably carved out of whales' teeth.

The hoard was first shown publicly at the Society of Antiquaries of Scotland on 11 April 1831 but was not recorded in the press until June of that same year when 'upwards of seventy pieces' were described as having been

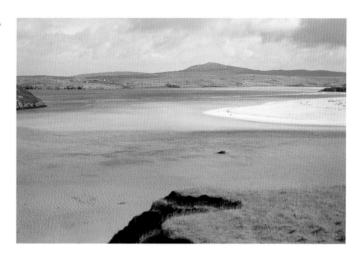

found by 'a peasant of the place, whilst digging a sandbank'. At this point the precise number of pieces had not been accurately observed, a problem that becomes increasingly perplexing as the plot develops. The peasant (from later accounts) seems to have been Malcolm Macleod of Penny Donald, Uig. Clearly uncertain about how to convert his treasure into cash, he sought the agency of Roderick Pirie, a merchant from Stornoway.

The transaction that took the hoard from Lewis to Edinburgh is not well documented. The pieces were shown to the Scottish Antiquaries 'by permission of Mr Roderick Pirie of Stornoway', which implies that he still had control over them. However, at this point or shortly afterwards they fell into the possession of the Edinburgh dealer, Mr T.A. Forrest, for the sum of £30. The exhibition of the hoard at the Scottish Antiquaries Society was a critical moment in its history: the excitement that it caused led to the possibility of the chessmen being split up. The Society was interested in buying a group of them for its museum and hoped to finance the purchase by selling off the remainder to its Fellows. However, this scheme was unsuccessful and so Forrest turned his sights to the British Museum, where he encountered Sir Frederic Madden (fig. 2).

Sir Frederic Madden (1801–73) was Assistant Keeper of Manuscripts at the time. He combined brilliance in scripts

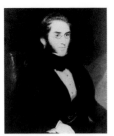

2 Sir Frederic Madden, painted in about 1837 by William Drummond.

and languages with a keen interest in board games. Consequently he was fascinated by what Forrest had to show him and communicated his enthusiasm to Edward Hawkins, Keeper of Antiquities. Hawkins, it seems, needed little prompting to appreciate the merits of the chessmen, but with steely resolve he haggled over the price. Forrest wanted 100 guineas, but Hawkins held out, finally paying 80. This must have been an agonizing period for Madden, who expressed his concerns in his journal entry for 17 October 1831 in rather understated language: 'The price asked for them is 100 gns. If our Trustees do not purchase them, I fear the sets will be broken up and sold separately, which will be a great pity.'

Eighty-two pieces of the Lewis hoard were eventually acquired by the British Museum between November 1831 and January 1832. Madden demonstrated great sensitivity in his desire to keep the hoard together; however, without his knowledge, its integrity had already been violated. Forrest had sold ten of the key pieces to Charles Kirkpatrick Sharpe, a member of the Scottish Antiquaries Society. Sharpe, significantly, also purchased a further piece – a stray bishop – from the Isle of Lewis itself. This suggests that the hoard was tampered with or partly dispersed before leaving Stornoway. Given that seventy-eight chessmen are now known to us, enough for at least four incomplete chess sets, the tantalizing question remains: were other pieces quietly disposed of in the same way? If so, are they still in private hands awaiting identification? The minimum missing pieces are a knight, four warders and forty-five pawns. Sharpe, it would seem, had not been offered the largest, most lustrous pieces or had refused to pay the price asked for them. In any event the process of dispersal was considered and calculated, implying an awareness of the potential value of the find and a willingness to wait for the best price – a thought process most likely to belong to a professional dealer in antiquities.

Sharpe's collection was sold off after his death in June 1851, giving the British Museum and the Scottish Antiquaries the opportunity to purchase his eleven chessmen. The two institutions worked together with a

view to the British Museum receiving three pieces and the Scottish Antiquaries acquiring eight. However, there was another interested party, Lord Londesborough, who in the final event was the successful bidder, buying the pieces for £105. His agent was none other than T.A. Forrest, the dealer who twenty years earlier had led Madden to believe that he was acquiring the entire hoard. His 'bad behaviour' over this deception was noted at auction by Sir Augustus Wollaston Franks, Keeper of British and Medieval Antiquities at the British Museum. When Lord Londesborough died in 1860 his collection remained intact. In 1888, however, it was sold at Christie's. This time the Scottish Antiquaries were successful in their bid, securing all eleven pieces on behalf of the National Museum of Scotland for 100 guineas (fig. 3).

Varying accounts of the discovery of the Lewis chessmen continue to come to light and cover a period of more than thirty years. New details most usually emerge each time the chessmen come to public notice. The earliest versions, drawn from local sources, were imbued with a love of oral narrative. Traditional tales were blended with recent fact or ancient superstition, and the colourful details were eagerly recorded by Antiquaries, desperate to discover more about the remarkable find.

From the beginning, local associations connected the chessmen with a legendary convent populated by the 'black women' of Uig. Madden refers to this myth in his first publication of the chessmen in *Archaeologia* in 1832, and it is repeated by Sharpe in a note to the Society of Antiquaries of Scotland in 1833. However, there seems to be no archaeological or documentary evidence for any such religious house. The details of discovery vary from a very summary journalistic note of June 1831 to a tale of fear, greed and the supernatural in an account by Daniel Wilson of 1851, which coincides with the reappearance on the market of Sharpe's eleven chessmen.

Wilson's survey, *The Archaeology and Prehistoric Annals of Scotland*, relates how the action of the sea swept away part of a sandbank, exposing a small stone chamber. A local peasant investigated the structure and was alarmed to

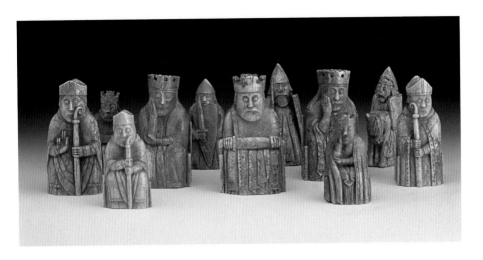

discover 'an assemblage of elves or gnomes upon whose mysteries he had unconsciously intruded'. Shaken and fearing for his safety, the peasant described what he had discovered to his fierce wife, who made him return to the spot and gather up the 'singular little ivory figures which had not unnaturally appeared to him the pigmy sprites of Celtic folklore'. The nuns reappear in Wilson's account, in which he suggests that the solitary women may have carved the chessmen to reduce the tedium of their cloistered life.

By 1863 a completely different turn of events was developed in 'Notes on the Lewis chessmen' by Captain F.W.L. Thomas for the *Proceedings of the Society of Antiquaries of Scotland* (IV, 1861–2). Thomas's sources seem to have been gathered locally on the Isle of Lewis. His tale involves a herdsman who saw a shipwrecked sailor swimming to safety with a bag on his back. The herdsman murdered the sailor for the riches he believed him to possess. Burying the sailor, he reported the shipwreck to his master, George Mor Mackenzie, and elaborated a scheme whereby the crew of the ship should be murdered for the cargo they were carrying on board. Mackenzie was outraged at this idea and instead accommodated the survivors at his house for a month. When the crew left the island, the wicked herdsman went to examine the contents of the bag that he had stolen, which turned out to be the pieces from

the Lewis hoard. In an attempt to dispose of the evidence against him, he then concealed the carvings in a sandbank in the Mains of Uig. Not surprisingly, the herdsman's behaviour went from bad to worse and he was hanged at Stornoway for his 'abuse of women'. Before his death he confessed to his misdeeds, including the murder of the sailor. Many years later, according to Thomas, the peasant Malcolm Macleod unwittingly stumbled across the incriminating evidence and sold the chessmen in Edinburgh through Roderick Pirie (here referred to as Captain Ryrie) for £30. Thomas concludes by citing the authority for the tale as follows:

> Such is the tradition, noted by Mr Morrison of Stornoway, who was for many years a resident in the parish of Uig and was intimately acquainted with the folk-lore of that district.

At the point of acquisition by the National Museum of Scotland an attempt was made to purge the accounts of local legend. The records simply state that the museum acquired eleven chessmen found in a stone chamber that had been exposed by the action of the sea. They are described as having been buried 15 ft (4.6 m) down and it is noted that they were slightly covered with sand with a heap of ashes on the floor next to them. The findspot is recorded as being close to *Tigh nan Caillachain dhu nan Uig* – the house of the black women of Uig.

Unaccountably, in 1928 the Royal Commission on Ancient and Historical Monuments introduced a cow into the cast of characters. This detail is incorporated into the fullest folkloric account, published as late as 1967. In Dr MacDonald of Gisla's *Tales and Traditions of the Lews* we are transported to the seventeenth century, when a herdsman known as 'Red Gillie' observed a ship anchored in Loch Hamnavay and saw a young boy take flight in a small dinghy. When confronted by the 'Red Gillie' the boy explained that he had jumped ship and that since he had no money he had taken the sailors' games to sell. The herdsman promptly killed the boy, buried him in a cave and

stole the bundle. He hid it in the sands of Uig but was then banished by his master after hatching a plot to rob the ship. Later the herdsman was arrested on another charge and, although he confessed his crimes at the gallows, the hoard remained undiscovered until Malcolm Macleod's cow inadvertently unearthed them with its horns. Macleod took the chesspieces to be 'idols or graven images of some kind which he did not understand'. Discomfited by the eerie nature of these objects, he passed the information to a 'gentleman from Stornoway' who 'dug out all the pieces'. Local memory has continued to relate how the chesspieces were displayed in Malcolm Macleod's barn, to the delight of children who travelled across the island to see them.

A foolish peasant, a grasping merchant and a slippery dealer; wealthy gentlemen and tireless scholars; a heartless herdsman, shipwrecked sailors and a house of melancholic nuns: all have played a part in the story so far. However, the real personalities are the chessmen themselves. Their universal appeal secures them a place in the hearts of millions of museum visitors every year and has even won them a cameo role in the film *Harry Potter and the Philosopher's Stone*. In one scene Harry and Ron familiarize themselves with the game of Wizard chess with a replica set of the Lewis chesspieces. The skill they develop in this game saves their skins when they encounter the enchanted, giant chess set guarding the Philosopher's stone.

The seventy-eight chessmen known to us today are grouped as follows. The British Museum has six kings, five queens, thirteen bishops, fourteen knights, ten warders (or rooks) and nineteen pawns. The National Museum of Scotland has two kings, three queens, three bishops, one knight and two warders. For simplicity's sake the British Museum pieces are referred to by the short reference number provided by O.M. Dalton's 1909 *Catalogue of Ivory Carvings of the Christian Era in the British Museum* (BM 78–159). The National Museum of Scotland pieces are denoted by the catalogue number given them in the 1892 catalogue of the National Museum of Antiquities of Scotland (NMS 19–29).

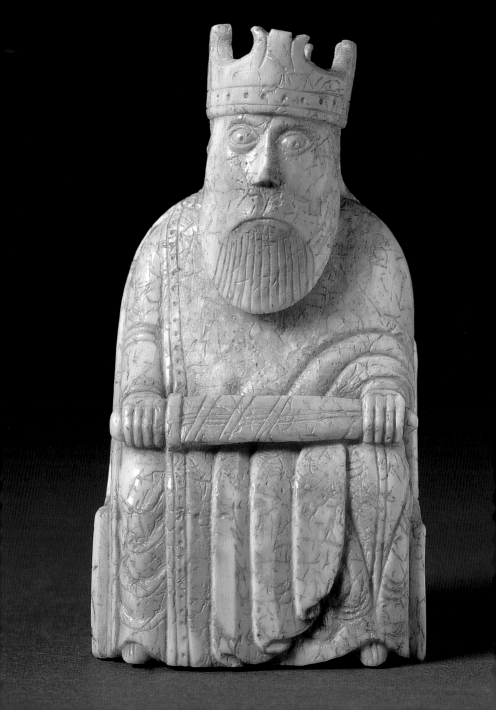

Chapter Two
Curious characters: the chessmen

4 A king (BM 78) with a particularly heavy beard.

The earliest surviving descriptions of the chessmen repeatedly refer to them as 'curiosities'. The more imaginative commentaries compare them with 'elves', 'gnomes', 'pigmy sprites', 'graven images' and 'idols'. However, Sir Frederic Madden also viewed them as works of art: the pieces serve as small-scale sculptures but share qualities with more monumental works in wood and stone of the same period, which is generally known as Romanesque.

The word 'Romanesque' was first used in the early nineteenth century as a way of defining Western European artistic life from about the middle of the eleventh century to around the early years of the thirteenth century. The period has since been termed the 'twelfth-century Renaissance' and the 'long twelfth century'. Each phrase was coined to convey the notion that such a phenomenal growth of ideas had not occurred since the times of ancient Rome. Artistic activity during this period was enriched by influences drawn from Classical Rome, Byzantium, Islam and Judaism. Centres of cultural co-existence were critical to the process of intellectual transmission. They were to be found in such cities as Venice and Constantinople (Istanbul), or the territories of Sicily, the south of Italy and the south of Spain, where communities of Christians (including Greek Orthodox), Muslims and Jews all lived together in relative harmony. There was a corresponding growth in literature, philosophy and science as Classical Greek and Roman texts, which had been preserved in Arabic translations, were made available and translated into Latin. Contemporary theories were translated in these same cultural centres, particularly from Arabic and Hebrew sources, leading to significant advances in mathematics, medicine and astronomy. The period was remarkable for the foundation of schools and universities such as those at Bologna, Paris, Oxford and Cambridge,

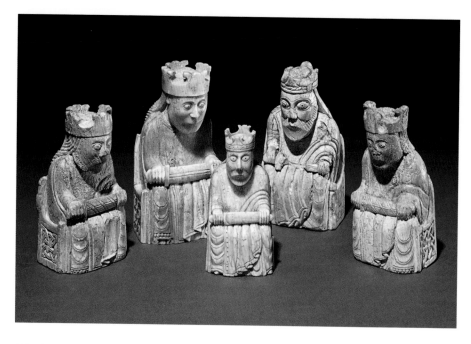

5 Five kings from the British Museum (BM 79–83).

each of which proved valuable in circulating the texts that were being produced.

The Lewis chessmen were carved precisely in this period of intellectual and artistic growth. They were made no earlier than 1150 and probably before about 1200, a date range which is borne out by the style of the carving and by details of the costumes that the figures wear. The question of their place of origin, however, will probably never be satisfactorily settled. A number of different suggestions have been made, describing them as English, Scottish, Irish, Icelandic, Danish or Norwegian. Occasionally, it has even been suggested that they were made on the Isle of Lewis, but the lack of archaeological evidence makes this a very distant possibility. The cultural and political ties of the Hebrides in the twelfth century (see p. 59) confirm the stylistic association of the chessmen with Scandinavia, and with Norway in particular. The Scandinavian world at that time included Denmark, Sweden, Norway, Finland, the Western Isles of Scotland, the Faroe Islands, Iceland and Greenland.

The kings

There are eight kings in total, all seated on highly ornate thrones (figs 3–5). Each grips a sword with both hands and rests it across his knees. Their cloaks are fastened above the right shoulder, leaving the right arm free to use the sword. The sword suggests conventional, physical strength, but also implies the administration of unswerving justice. The paternal characteristic of the kings is reinforced by the beards that most of them wear. Some of the beards are heavier than others, particularly BM 78 (fig. 4), which is drawn with strongly incised lines. Two of the kings are unusual in being clean-shaven (BM 79 and BM 81). Their hair is generally arranged in thick braids across their backs and shoulders, according to the regal fashion of the time. One (BM 81), however, is alone in having shorter, shoulder-length hair.

The queens

All eight queens occupy thrones of similar construction to those of their kings (figs 3, 6 and 7). They wear veils underneath their crowns, a fashion of the late twelfth century represented, for example, in the Madonna and Child of the Lisbjerg altar in the National Museum of Denmark at Copenhagen, which dates to about 1150. The same headdress is worn by the female symbol of the Church used on the walrus-ivory cross of Grunhild in the same collection, dated to between 1150 and 1180.

Each of the Lewis queens assumes the characteristic pose of chin resting in the right hand, which is usually supported at the elbow by the left hand. There are three slight variations in rendering this gesture. One (BM 85) holds a veil or a length of drapery between the fingers and thumb of her left hand, and two others (BM 84: fig. 7; and NMS 23) are given a horn to hold which they clasp in their left hands. This is likely to be a drinking horn, the significance of which is not certain. Used by all levels of society, they could be crafted from the walrus tusk or the humble cow horn. Their natural shape meant that they could not be set down but had to be held until the contents were drunk (which was frequently achieved with speed).

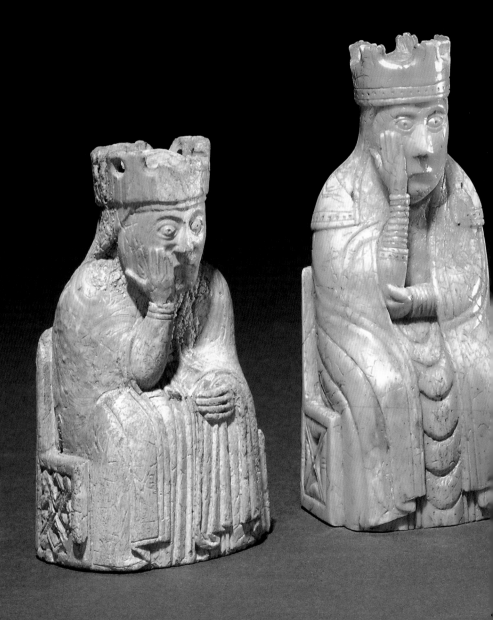

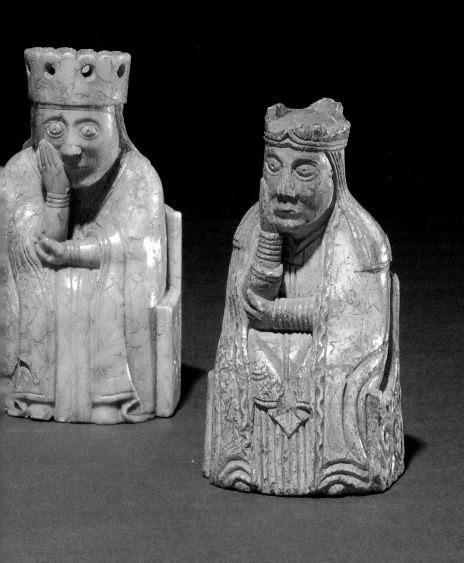

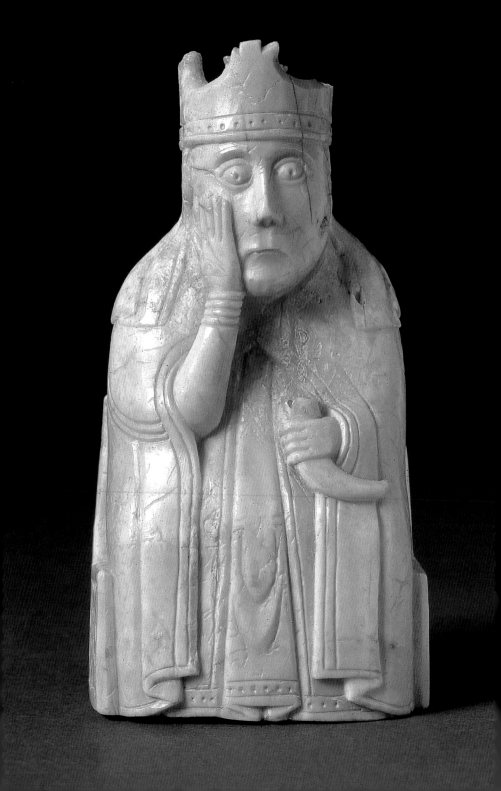

The queens may well be bearing the drinking horn for
the benefit of their kings.

There are two broadly different ways of depicting
drapery in the carving of the queens. Some display a greater
economy of style and present more polished, lustrous
surfaces (BM 84 and 88), and others show stronger lines
and more tightly compacted folds (BM 87 and NMS 22).
This stylistic difference within the conventions of fashion,
evident in some of the other pieces to a greater or lesser
degree, probably indicates more than one hand at work
on the chessmen. Whether it might also imply that they
were the products of more than one workshop is harder
to establish.

The bishops

Of the total sixteen bishops, seven are seated on thrones
and nine are standing (figs 3, 8 and 9). They wear mitres,
the ceremonial headdress of bishops, and they all carry a
crozier, their hooked staff of office. Some of the standing
bishops grip their croziers with both hands while others
secure them with one hand, holding a Bible in the other
(BM 93: fig. 9) or making a sign of blessing. They are
dressed either in copes, which are fastened at the neck,
or chasubles, which enclose the body entirely.

The presence of the bishops among the Lewis chessmen
is significant in terms of the dating of the pieces. By about
1150 the fashion was established for bishops to wear their
mitres facing frontally, as here, rather than sideways. This
change is noticeable in the representation of bishops on
seals attached to twelfth-century documents. Furthermore,
no earlier representation of the figure of a bishop in the
game of chess is known to have survived. So although it
is unlikely that the Lewis bishops were the first such
chesspieces to be invented, it can at least be stated with
some confidence that the bishop was a twelfth-century
innovation. What might be the reasons for this? It has been
suggested that, given the Church's disapproval of board
games, combined with the clergy's undoubted enthusiasm
for the game of chess, the arrival of the bishop on the
board might be a satirical comment. However, as will be

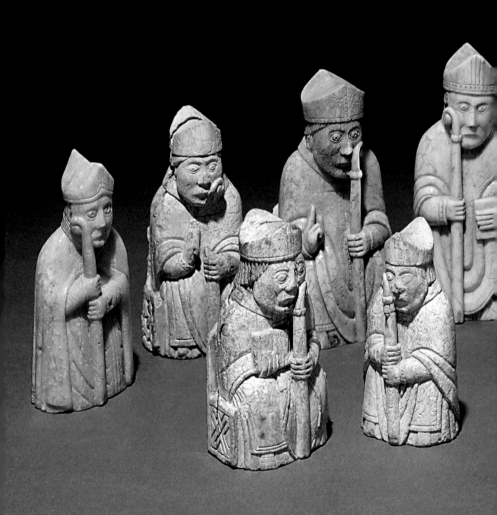

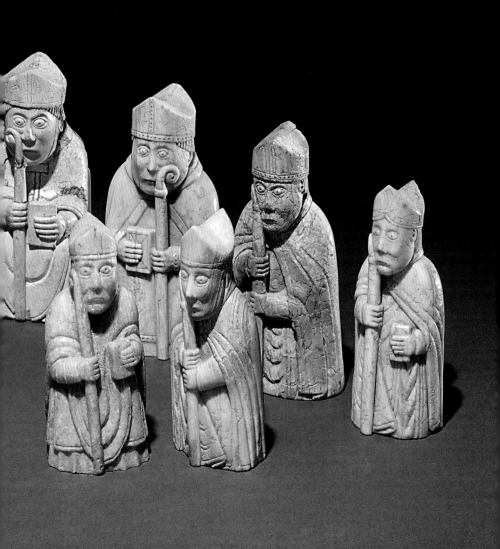

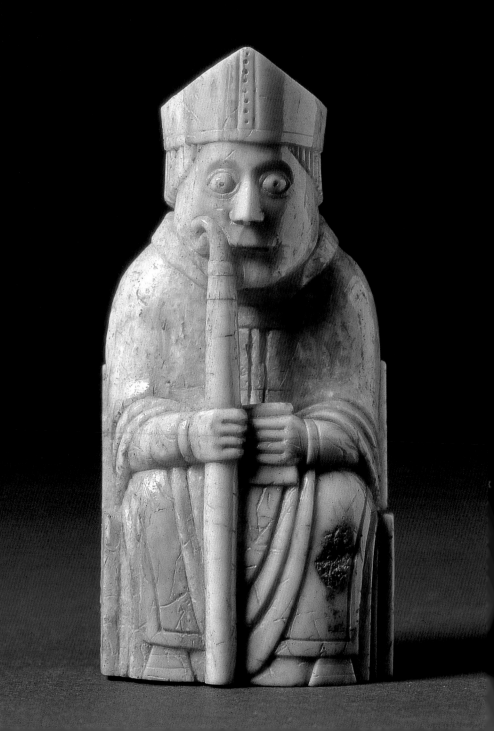

8 *Previous page* Twelve
bishops from the British
Museum (BM 89–92,
94–101).

9 A bishop (BM 93)
holding a crozier in one
hand and a Bible in the
other.

demonstrated below (pp. 47–51), the Church's attitude
became increasingly relaxed towards the end of the twelfth
century, and, by the thirteenth, chess terminology was even
being used widely in sermons.

The bishop's inclusion undoubtedly reflects his status in
the social system of the period. Although the bishop takes
a place on the chessboard beneath the king and queen, his
presence is a token of the importance and power of bishops
pushed into positions of ever greater political prominence.
Disputes between Church and State had been rife
throughout the eleventh and twelfth centuries. In 1170,
however, the Church was given a martyr to the cause by
the sacrilegious murder of Thomas Becket, Archbishop
of Canterbury. His death was a direct consequence of his
disagreement with Henry II over the privileges due to the
Church. In 1173 Thomas was proclaimed a saint and Henry
II was publicly penitent. The most extensive period of
conflict in Norway's civil wars was exacerbated by the
involvement of bishops known as the Baglar or 'croziers'.
They fought under the leadership of the bishop of Oslo
between 1196 and 1202 to prevent the erosion of Church
privilege. Could the Lewis bishops even be directly
connected to the emergence of the Baglar? Regardless of
how convincing an argument this might be, the concept
of the warrior-bishop could well explain why it was an
appropriate addition to the chessboard. The game of chess
is a war game, and, at least from the time of the First
Crusade in 1095, bishops could be found increasingly on
the battlefield. During the course of the Third Crusade, for
example, the bishops of Lydda and Acre went into battle
at Hattin, near the Sea of Galilee, in July 1187, carrying
before them the relic of the True Cross.

The knights
The fifteen knights sit astride sturdy ponies with shaggy
manes which appear almost Icelandic in character (figs 3,
10, 20 and 29). They all wear helmets and are armed for
battle, carrying spears and shields, with swords slung
around their shoulders. The knights provide a wealth of
information about the arms and armour in use in the

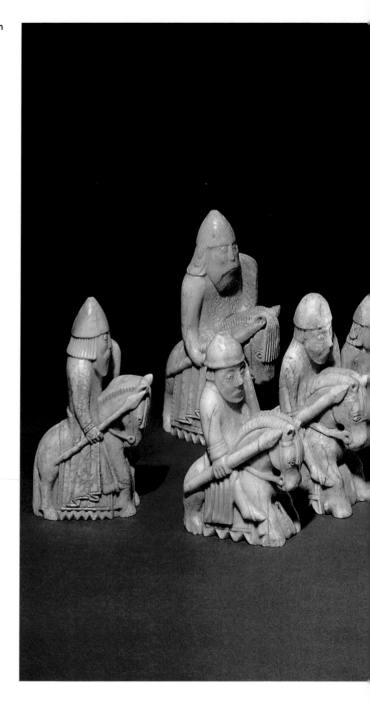

10 Eleven knights from the British Museum (BM 103–10, 112, 114–15).

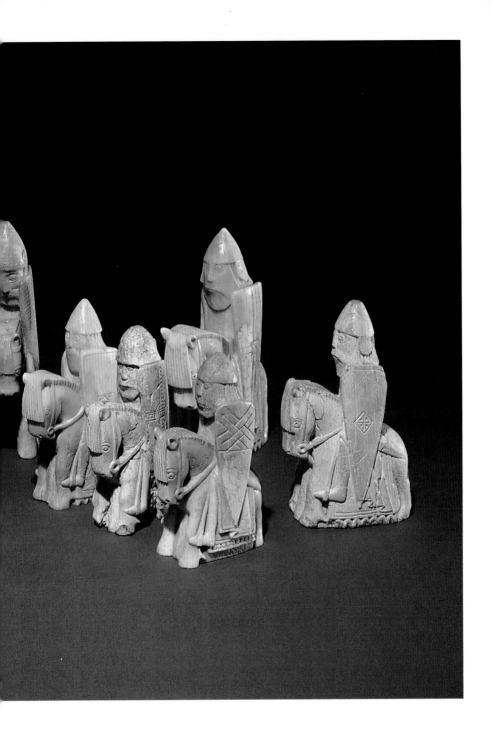

second half of the twelfth century. Their headgear includes the pointed, conical helmets with earflaps and nasal guards which were adopted from the eleventh century, and compare with those depicted on the Bayeux tapestry (*c.* 1066–82). They also wear distinctive rounded helmets, with or without a rim, which resemble bowler hats and are known as *chapels-de-fer* ('iron caps'). This type of helmet appears on seals of the late twelfth and thirteenth centuries showing knights on horseback. Their kite-shaped shields have either a rounded or a flat top. Each shield has a distinguishing design which emulates the adoption of heraldry, usually considered to be widespread by the end of the twelfth century.

The warders or rooks

There are twelve warders, all of whom defend themselves with shields decorated in a similar fashion to the knights' (figs 3, 11, 12 and 21). They are represented as foot soldiers and each carries a sword. All wear helmets, apart from one (BM 125) who, along with three others (BM 123, 124 and NMS 29), bites the top of his shield in the most disturbing manner (fig. 12). It was Madden's expert knowledge of Norse sagas – the long histories of the northern races – which solved for him the meaning of this puzzling gesture. He published his finding in his 1832 article about the chessmen for *Archaeologia*, quoting the *Heimskringla* of Snorri Sturluson (*c.* 1179–1241). Sturluson was born in Iceland into a Christian society with a vivid but often fanciful awareness of its pagan past. He writes:

> The soldiers of Odin went forth to the combat without armour, raging like dogs or wolves, biting their shields, and in strength equal to furious bulls or bears. Their enemies lay prostrate at their feet: neither fire nor weapons harmed them; this frenzy was known as Berserksgangr.

'Berserker', which gave us the modern word 'berserk' to describe a violent frenzy, may originally have meant 'bare-shirt' (i.e. shirtless) or, equally, 'bear shirt' (i.e. a shirt made of bear skin). Both terms express wildness. The

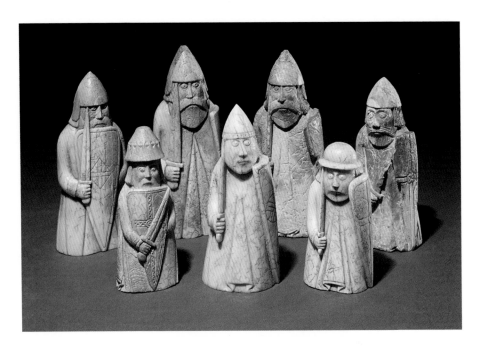

11 Seven warders
(rooks) from the British
Museum (BM 116–19,
120–22).

Lewis berserkers are protected by armour, and, although
one lacks a helmet, it is the specific act of biting the shield
that communicates their frenzy and places Madden's
recognition of the gesture beyond a doubt.

The pawns

The nineteen pawns all take very much the same, simple
form (figs 3, 13 and 14). They are the only pieces not to be
represented in human shape. Their origins in the history
of chess (see p. 45) might suggest that they would more
properly be represented as foot soldiers, but this status is
given to the rooks among the Lewis chesspieces. The pawns
instead appear as inanimate, standing slabs of walrus ivory
which have no firm identity in the social world embraced
by the chessboard. Later, in the final quarter of the
thirteenth century, the Italian preacher Jacobus de Cessolis
personified the pawns as craftsmen, labourers, innkeepers
and merchants.

Most of the Lewis pawns are octagonal in shape, rising or
tapering to a curved top. This terminates in a small button

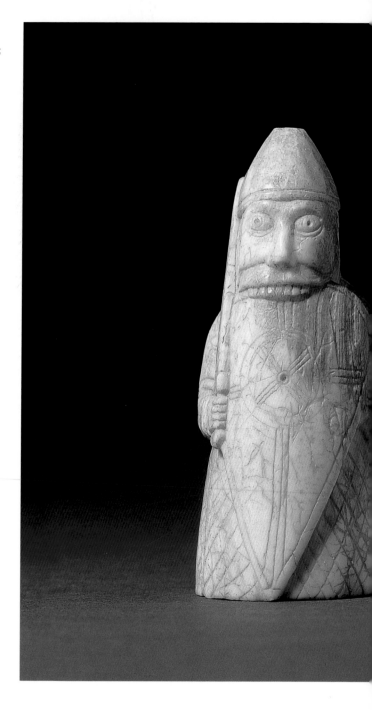

12 Three berserkers from the British Museum (BM 123–5); a fourth is in the National Museum of Scotland (see fig. 3).

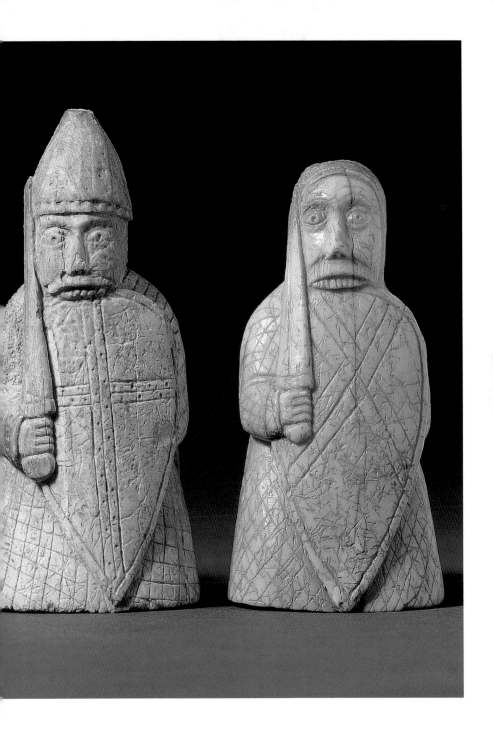

13 and 14 A selection
of pawns from the total
of nineteen (BM 126–8,
132–44).

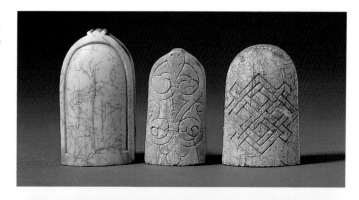

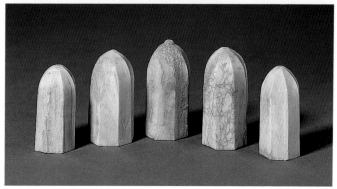

in one example (BM 132). The least angular have slightly
concave surfaces (BM 129, 130 and 131). Other variations
are provided by two flat pawns with engraved surfaces
(BM 127 and 128) and one larger flat pawn with a small,
three-pointed crest (BM 126). The pawns represent the
greatest variety of sizes of all the pieces that were found and
must, therefore, demonstrate the highest number of losses
if we assume that they belonged to sets of comparable size.
As a line of argument this could also suggest that in excess
of four complete sets were deposited in the sand dune.

Stylistic considerations
Apart from minor variations in dress, beard, hair or stance,
all of the figures have the same facial features: prominent
staring eyes, down-turned mouths and slightly protuberant
upper lips. This homogeneity was quite usual in a period

that did not think in terms of individual portraiture. A great deal more energy is employed on the backs of the thrones of the seated pieces. These small spaces are given over to decorative devices which range from animal-based ornament to architectural motifs. Exuberantly carved foliage falls in festoons (BM 90 and 91: fig. 15) and interlocking arches are balanced by the precision of geometric interlace (BM 92); beasts disgorge the frames of the thrones and confront one another in a swirling mass of tendrils (BM 85 and 86: fig. 16), or consume themselves in a frenzy (BM 78: fig. 17). Each throne displays unique carvings drawn from a repertoire of forms used in manuscript illumination, church architecture and metalwork.

Other walrus-ivory products from the period, however, provide some of the closest comparisons. A reliquary in the British Museum (M&ME 1959,12-2,1) is cleverly constructed from a whole walrus tusk and dates from the middle of the twelfth century. The similarity of its elaborate scrollwork to that presented by some of the Lewis chessmen's thrones is clear (fig. 18). Interestingly, before it was converted for use as a reliquary in the fourteenth century, the tusk may have served as the leg of an ivory chair or throne which would probably have been decorated

15 Reverse view of three seated bishops (BM 90–92), showing the foliate and architectural decoration of the thrones.

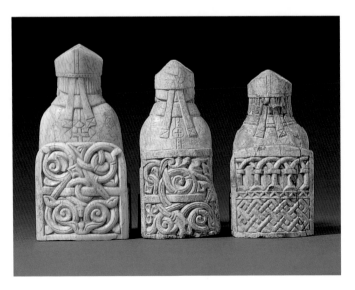

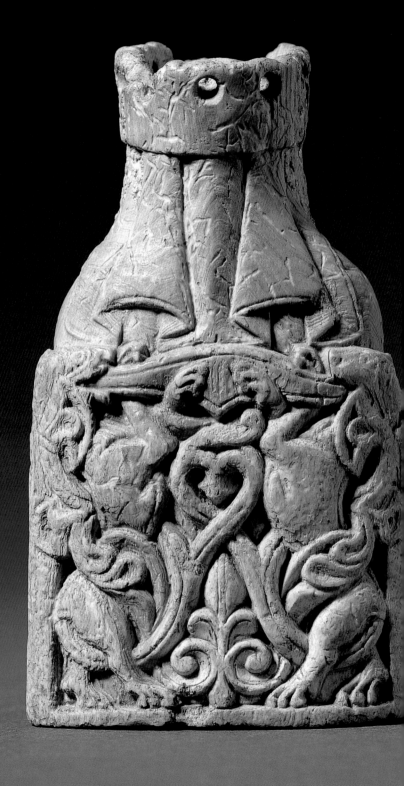

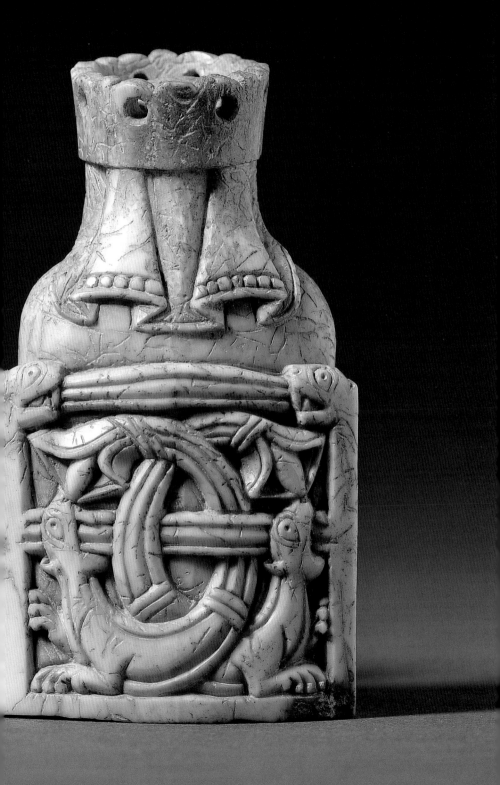

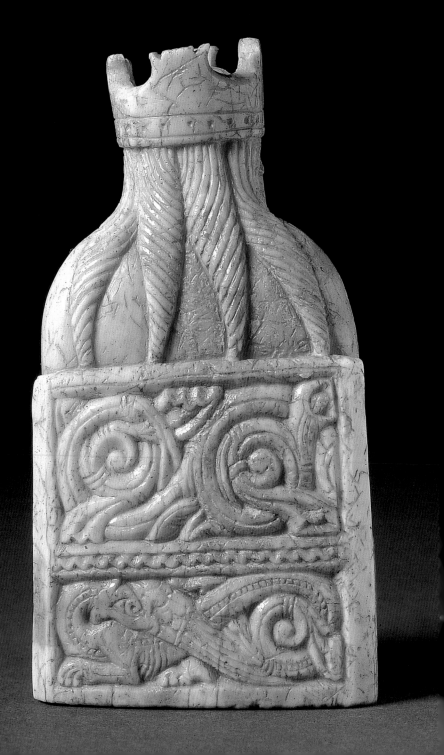

in exactly the same manner as the Lewis thrones.
The mounts that were attached to it in the course of its
conversion confirm its Scandinavian origins. Examples of
walrus-ivory objects in the National Museum of Denmark
in Copenhagen include a Scandinavian buckle which dates
from the second half of the twelfth century and resembles
that found with the Lewis chessmen (fig. 19).

The relevance of more monumental, architectural forms
is difficult to assess in relation to the style of carving used
on the chessmen. This is because the merits of church or
cathedral architecture in relation to the less public
commissions of smaller-scale works has never been
satisfactorily resolved. Architecture is generally considered
to be a field of innovation, but the scarcity of documentation
in other areas of the arts means that the line of descent or
the routes of influence are not clear.

However, the stone sculptures from churches in
Trondheim, Norway, offer points of comparison from the
second quarter of the twelfth century. The connection with
Trondheim is alluring partly because of the good evidence
for walrus-ivory workshops there (see p. 58). The fragment
of a queen chesspiece found in the chancel of St Olav's
parish church in Trondheim in the nineteenth century
exists now only in the form of a drawing but demonstrates
a close resemblance to the Lewis queens. The existence of
additional, individual chessmen in museums in Ireland,
Sweden, Italy and at the British Museum that relate to

18 Detail of a reliquary
constructed from a
whole walrus tusk;
Scandinavian,
1150–1200.

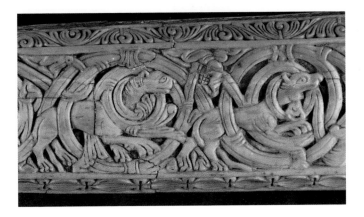

19 Engraved belt buckle (BM 145) found with the Lewis chessmen.

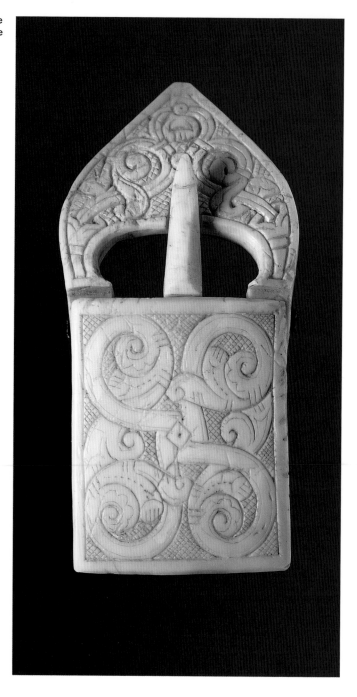

those found on the Isle of Lewis, along with one described by Madden in 1832 found on the west coast of Scotland (now lost), suggests a sustainable regard for figurative pieces in this style. Identifying the exact nature of their attraction for the people of the time is a challenge, however. Were the chessmen, in fact, meant to be comic?

The comic appeal of the chessmen

The shape of the walrus tusk inevitably led to chesspieces being carved in a variety of sizes, since the tusk narrows from a wide base to a sharp point. Consequently there is a 3-cm difference in height between the largest king (10.2 cm) and the smallest (7.3 cm). The most diminutive of the pawns measures only 3.5 cm high. The comic combinations that are possible as a result of disproportionate sizes being placed together, and the subsequent humorous dialogue that can be set up between a small and a large piece (BM 102 and BM 113: fig. 20), was probably not the way in which the chessmen were designed to be seen. Pieces of equal or near-equal size must surely have formed one set.

In a few instances some of the chessmen depart from the stylistic norm. Of all the knights, for example, BM 102 is set at the most precarious angle, with the most agitated drapery. Another example is a warder (BM 119: fig. 21), which is the only piece not to have a completely frontal orientation. His slightly sideways glance creates a comic moment. However, in both these instances the modelling of the pieces was probably determined by the difficulty of cutting the tusk, although the carver has in the latter case, admittedly, exaggerated the sideways glance by positioning the pupils of the eyes off-centre.

The Berserkers (figs 3 and 12), although irresistibly comic to a modern audience, were probably not conceived as figures of fun but as serious fighting machines who embodied an heroic ideal. They appear in a literary context, for instance in Sturluson's previously mentioned *Heimskringla*, as an expression of poetic nostalgia for a lost, golden age. Rather as with characters from the pagan Classical past, the heroes of Norse mythology may have been used as symbols for the coming of Christianity.

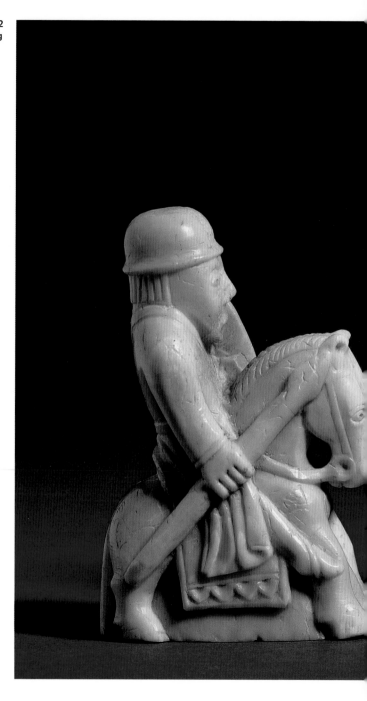

20 Two knights (BM 102 and 113) demonstrating the different scales of the chessmen.

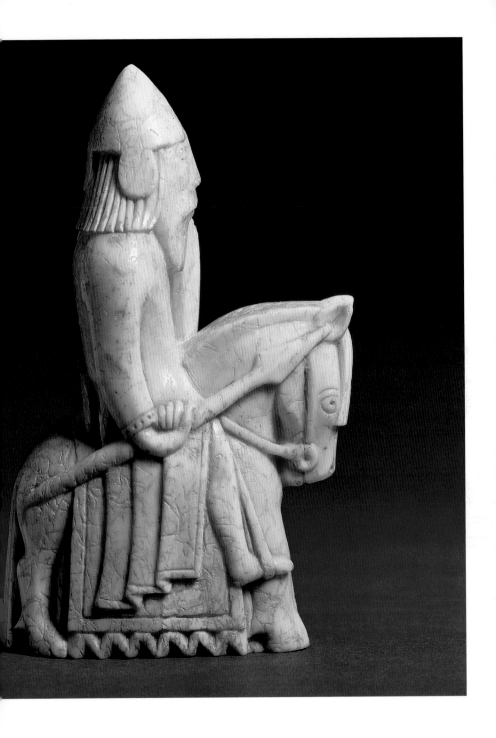

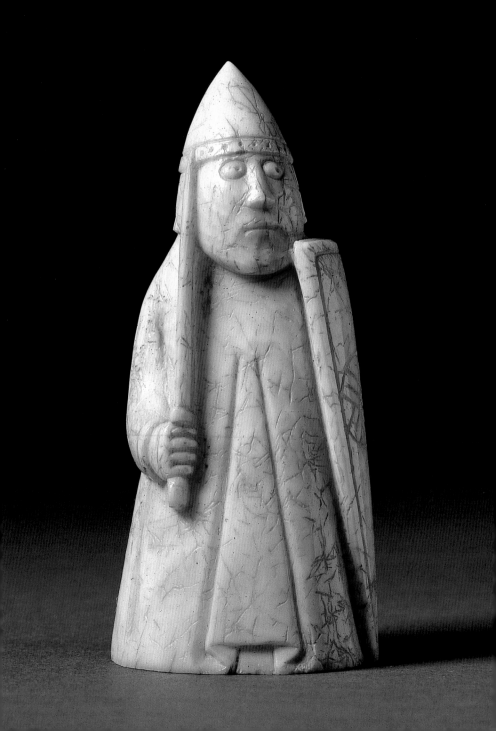

The kings, although seated, convey the threat of action and are poised to pounce in the very act of drawing their swords from their sheaths. The portrayal of the monarch, ruling wisely and exacting justice with a firm hand, was also very popular in the literature of the time. The queens, often viewed by a modern audience as looking bored or worried, are rather more likely to be communicating contemplation, repose and possibly wisdom. The clue to their psychology is offered by the history of the queen in the evolution of chess, which will be explored below in Chapter Three.

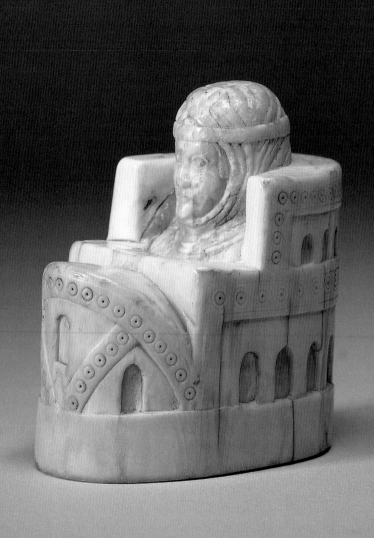

Chapter Three
Leisure and learning: chess in the 'long twelfth century'

The origin of chess

From its very beginnings chess was conceived as a complex game of strategy and skill. The identification of its origin has, however, been set with difficulties. It was possibly devised by a sole intellect and many creditable individuals have been suggested. Aristotle, Galen and Hippocrates aside, a favourite theory from the medieval period was that Palamedes, brother-in-law to the beautiful Helen, concocted the game to relieve his boredom during the lengthy siege of Troy. A wall-painting from the tomb of Queen Nefertari of Egypt, dating from about 1250 BC, shows the queen playing with gaming pieces which resemble those used in chess: for some, this pushed the origins of the game even further back in time. Other early theorists went to the very creation of man and cited Adam as inventing the game to console himself for the death of Abel.

From medieval times associations were made between chess and the Classical past. This proposed connection was perpetuated by later authorities working from the understanding that all noteworthy achievements sprang from the societies of ancient Greece and Rome. Although its origins are sketchy owing to the lack of documentary or archaeological evidence, it does seem probable that chess developed in India in about the sixth century AD, spreading from there west to Persia and then into the Islamic territories. This theory was established in 1694 by the scholar Thomas Hyde. It was the study of chess terminology that secured the importance of its oriental past. The oldest known chess books, gathered from fragmentary sources, are of Arabic origin and date back to about AD 850. The existence of these compilations implies that the game was widely played and well established by this time. The consensus of opinion of all the Arabic authors on chess throughout the ninth and tenth centuries is that it reached

43

the Islamic world from Persia, where it had in turn arrived from India. The Arabic word for chess is *shatranj*, derived from the Persian *chatrang*, which in turn is taken from the Sanskrit *chaturanga*. *Chaturanga* means 'four bodies', reflecting the four divisions of the Indian army: chariots (rooks), elephants (bishops), cavalry (knights) and infantry (pawns). This categorization persists to the present day with few (though significant) changes. The earliest known excavated Persian chesspieces are from Afrasiyab, Samarkand, and date from the seventh century. The first datable Islamic chesspieces are from the ninth century: found at Nishapur in Iran, examples are now at the Metropolitan Museum of Art in New York. Persia succumbed to Arab forces in the 640s and almost immediately Arab translations of key Persian works began to proliferate. In all probability, chess was spread by the same process and was widely established in the Near East by about AD 800.

The early evolution of chess in Europe
The piece that clings closest to its nominal origins is the rook. Ultimately this comes from the Persian *rukh*, meaning 'chariot'. In the Indian game it was sometimes represented as a war chariot. During the course of its evolution, it was transformed into the castle – an ironic image for such a swift-moving piece, although one that describes its defensive potential. The terms used to identify chesspieces in the earliest Western literature associated with the game were taken from the Arabic, either as transliterations such as *rukh* into *rochus* (rook) or by translation into Latin such as the Persian and Arabic *shah* into *rex* (king).

Other pieces in the medieval game assumed a different form altogether. The Persian 'farzin' eventually became the Arabic 'vizier' or counsellor; however, in the European game this piece became the queen. The Lewis queens' head-in-hand pose probably relates to the role of the vizier as advisor and expresses thoughtfulness. Yet there is also a Christian influence: the same pose is adopted by the Virgin Mary at the foot of the cross in twelfth-century Crucifixion scenes, and by Adam pondering the loss of Paradise in

eleventh- and twelfth-century Byzantine ivories. In both cases there is an element of despair or grieving, but the emotional focus is really on contemplation – in these instances on the consequences of sin. An alternative identification of the horns that two of the queens carry (see p. 15) is offered by Sturluson's epic *Edda*. In this poem the horn is used by a queen to contain money. A money horn is an attribute that would fit well with the queen's role as advisor.

Rather as with the bishop, the appearance of the queen on the chessboard would not have seemed strange. By the close of the twelfth century enough formidable queens had wielded sufficient power to provide a precedent. In England, for example, Henry II's problems with Thomas Becket were barely over when those with his queen, Eleanor of Aquitaine, began. Eleanor supplied military support against Henry in 1173 in favour of their sons and consequently spent much of the remainder of Henry's reign in captivity.

It has already been noted (p. 19) that the bishop was a twelfth-century innovation to the European game. Before that time the piece is occasionally referred to as 'prince' or 'leaper', but ultimately it derives from the Indian 'elephant'. The ancestry of the knight can be traced back to the 'cavalry' of the original game, the pawn being the 'foot soldier' or infantryman. The Lewis pieces seem to conform to Scandinavian practice by representing their rooks as foot soldiers and leaving their pawns as blank, characterless and abstract monuments. As such they resemble, more closely than the other Lewis pieces, the abstract forms used in the Arabic game of chess. These abstract forms were designed to suggest the function of the piece without being literal representations. Thus the elephant became a double-domed piece to reflect the shape of the two riders on its back; the rook became a two-pronged silhouette of the original Indian war-chariot; and the king and queen became throne-like in their form. This throne-like structure has been made explicitly into a queen in one quizzical chesspiece that survives at the Walters Art Museum in Baltimore (fig. 22). Dated to the twelfth century and

considered to be Spanish on the basis of the style of headdress, it makes the relationship between the abstract and the representational very clear.

Other individual pieces also play with the question of form. Of all of the abstract pieces, the knight is most commonly recognizable by either the shape of a horse's head or a crude representation of one. The whale-bone chesspieces found at Witchampton Manor, Dorset (fig. 23), appear to anticipate the Lewis pawns in their abstract shape and bear elements of figurative design. They also demonstrate one of the difficulties associated with finds of abstract gaming pieces: if they are not discovered with other datable finds, it is extremely hard to place them stylistically, particularly since the fashion for using such pieces never entirely died out. Many may have been Islamic imports rather than European products. Where they are not found in sufficient numbers, even their identity as chesspieces cannot be certain. The Lewis chessmen are remarkable in that enough of them survive for us to be certain that they are chesspieces, and they are of such rare sculptural quality that there is little doubt as to their twelfth-century North European origins.

The twelfth-century appreciation of chess

The game of chess prospered in the environment of swift cultural exchange and revolutionary learning that characterized the period from the middle of the eleventh to the middle of the thirteenth centuries. The peaceful dialogue with the Islamic world that occurred in the south of Spain, Sicily and the south of Italy nominates these important cross-cultural centres as the best candidates for the transmission of chess into the rest of Europe. The celebrated chessmen in the Cabinet des médailles in Paris provide very visible evidence of a connection between the south of Italy and the game of chess. Long associated by legend with Charlemagne, they are in fact more likely to have been produced in Salerno at the end of the eleventh century.

The importance of southern Italy and Spain in the early history of chess in Europe is strengthened by the few documentary sources that survive. The monastery of

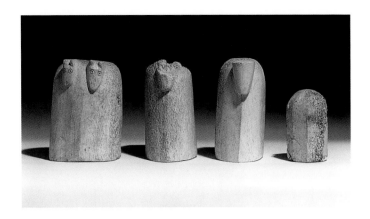

Einsiedeln in Switzerland has two very rare manuscripts that refer to the game. The earlier probably dates from the 990s. Both contain a lengthy poem describing the game of chess and setting out its rules. Significantly, the poems compare chess favourably with games of dice and place it on higher moral ground in terms of the level of skill required. The distinction is one that is repeated throughout the course of the development of chess in the medieval period. The association between chess and games of chance, such as dice, made the Church uncomfortable. Chess was repeatedly forbidden to clerics, who nevertheless nurtured it in the centres of learning where they gathered. Slowly the line of argument expressed by the Einsiedeln verses, that chess was an elevating activity, gained greater currency. One logical route for the spread of the game to Switzerland is through Italy, where it must have been played towards the end of the tenth century. Other arguments suggest that Theophano, the Byzantine wife of the Holy Roman Emperor Otto II, transmitted a knowledge of chess through her royal patronage of Einsiedeln, documented in 984.

At roughly about this time, the wealthy Ermengaud I, count of Urgel on the Spanish Marches, left his chessmen to the monastery of St Gilles, which was probably close to Nimes. His will dates from around 1008–10. Ermengaud's sister-in-law, Countess Ermesind, made a similar gift to the same monastery in 1058. In her will the pieces are described as being made of rock crystal: chessmen made

for a very elite market were often carved not just from bone and ivory but also from jet and (as here) rock crystal. The carving of the latter was a skill practised by Islamic craftsmen and imitated by Europeans. The bequests made to the monastery of St Gilles identify a route for chess into the south of France through Spain.

A similar process of transmission through Sicily brought the game to Italy where, by the middle of the eleventh century, chess was established enough to have its critics. The ardent Church reformer, Peter Damian, is unambiguous in his condemnation of the game. In about 1061–2 he wrote to the Pope-elect, Alexander II, describing an incident involving the bishop of Florence. He begins with a general complaint about the worldly behaviour of the clergy: 'I blush with shame to add the more disgraceful frivolities, namely hunting, hawking and especially the madness of dice or chess.' He then explains how it came to his notice that the bishop of Florence had spent an evening playing at chess. He challenged the bishop by reminding him of the Church's position on games of dice and chess for the clergy. The bishop defended himself, unsuccessfully, by making a distinction between the two games that Peter Damian refused to accept. Damian makes his position very clear when he concludes his letter to Alexander II with the following statement: 'But this we have said that it may be known from the correction of another, how shameful, how senseless, nay how disgusting this sport is in a priest.' This episode clearly demonstrates that the Church experienced difficulty in convincing the clergy to see chess as quite the repugnant occupation that Peter Damian held it to be.

The potential association with gambling was developed in the literature of the period, which used chess as a way of defining moral behaviour. The poem *Ruodlieb*, written by a German monk in about 1070, contains a sequence of chess games critical to the plot and vital to the depiction of the hero as a virtuous knight. Ruodlieb is sent on a mission to negotiate peace with a defeated king. He encounters the suspicion of the king's viceroy, who invites him to play a game of chess. One game leads to another and the contest continues for five days, Ruodlieb deciding when to lose as

an act of courtesy. On the fifth day the king himself invites Ruodlieb to play against him, which throws Ruodlieb into a dilemma:

> I declined firmly by saying 'It is fearful and lamentable to play against a king.'... The king smiled and said as if in jest 'My dear fellow, there is no need for you to have any fears in this matter. I shall not be roused to anger if I never win, but I want you to play with me as intently as you can; you see, I want to learn the moves you make that I am ignorant of.'

Ruodlieb agrees to play and wins three times against the king, who then begins to bet heavily until he has nothing more to lose. His courtiers step in and try to win but also fail miserably. The winnings by this time are very considerable, but Ruodlieb does not want to gain from gambling. His modesty in hesitating to accept the king's challenge to play, and his reluctance to profit from his skill, illustrates the importance of social etiquette and implicitly expresses a disapproval of gambling. Chess here is also being used as an indicator of wise rule. It is cited repeatedly in histories or Romances as an indication of a king's worth. Snorri Sturluson's *Heimskringla*, written in about 1230, describes a much earlier event involving a game of chess between King Cnut and Earl (Jarl) Ulfr:

> And when King Cnut and Ulfr the Jarl were playing chess, the King made a bad move and the Jarl then took a knight from him. The King put his men back and said he should play another move. The Jarl grew angry and threw down the chessboard.

The saga goes on to relate how Cnut had Ulfr murdered the next day. Madden quoted the exchange between Cnut and Ulfr to suggest that chess might have been introduced to the British Isles by King Cnut, who ruled in England from 1016 to 1035. H.J.R. Murray's comprehensive *History of Chess* (1913) entertains the possibility that Cnut may have become familiar with chess on pilgrimage to Rome in 1027,

but it is impossible to determine whether the incident has any basis in fact. It seems much more likely that Sturluson is using a literary convention by which chess is an indicator of good or bad behaviour. The ability to play chess had become an important qualification for the heroes of the epic poems of chivalry composed between 1150 and 1250. Through the agency of such literature chess was absorbed into the ritual of love and courtship in the fourteenth and fifteenth centuries. But it is unlikely that the figure of the fair knight who played well at chess was purely a literary invention. Guidance on appropriate behaviour was provided by instruction manuals produced in large numbers in the twelfth century, some of which promoted chess as a social accomplishment.

In his progress through Spain, France and England the Spanish cleric Petrus Alfonsi (1062–1125) demonstrates perfectly how intellectual influences were transferred from country to country. His personal profile embodies the rich cultural mix that was so much a symptom of life in Spain at the time, Petrus being born a Jew and converting to Christianity in 1106. He later travelled to England where he seems to have acted as the personal physician of Henry I. In the early years of the twelfth century he wrote the *Disciplina Clericalis* (*The Clerk's Instruction*). In his chapter 'On the Seven Liberal Arts, the Seven Knightly Skills and the Seven Rules of Good Conduct' he states 'The skills that one must be acquainted with are as follows: riding, swimming, archery, boxing, hawking, chess and verse-writing.'

Some knights, however, due to their special status were specifically forbidden chess. The crusading Knights Templar were allowed to joust, to make wagers with candle wax and to play some board games, but not chess and backgammon. Their rule, which was confirmed at the Council of Troyes in 1129 in the presence of St Bernard of Clairvaux, also forbade them the worldly pleasures of hawking and hunting.

The religious scruples that determined this type of policy gradually shifted during the course of the twelfth century with regard to chess. The prohibition on the clergy playing the game had never been very convincing: not only was

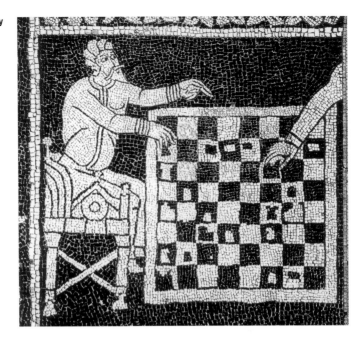

24 Early twelfth-century floor mosaic from the church of San Savino, Piacenza, executed in black and white and representing a game of chess.

most of the early literature on chess circulated by monks and friars but the symbolic sophistication of the game lent itself very well to moral lessons. Increasingly the image of the chessboard was used to instruct. The meaning of the marvellous mosaic pavement in the sanctuary of the church of San Savino at Piacenza (fig. 24) is not entirely clear. It dates from the early twelfth century and features a mysterious game of chess in which only one of the players is completely visible. His opponent is shown by an arm which descends on the chessboard from outside the picture plane. This may simply be an artistic solution to a lack of space. Some interpretations of the mosaic describe it as a chess lesson. However, it seems more likely that the chess game is being used to amplify the central scene of the mosaic, which represents the Wheel of Fortune. It shows a wheel being rotated by a supernatural force; the characters clinging to the frame of the wheel find themselves rising and falling according to the whims of Fortune. Might this mosaic be an early representation of the morality game of chess played against Death or Fortune, a symbolic encounter which

became increasingly popular from the thirteenth century? In any case, the fatalistic insistence on accident in the mosaic's design appropriately reflects the notion of chance versus skill played out in a game of chess.

The skill, strategy and sheer struggle of chess-play is used as a powerful image in a work by Richard of Ely produced in 1177. His *Dialogus de Scaccario* (*Dialogue of the Exchequer*) takes the form of a series of conversations between a master and a scholar, explaining the administration of the Exchequer. The Exchequer took its name from the large, chequered cloth used to assist in financial calculations. Richard makes its association with chess explicit in response to the scholar's question of how the Exchequer received its name:

> I can think ... of no better reason than it resembles a chessboard....
>
> For as on the chessboard the men are arranged in ranks, and move or stand by definite rules and restrictions ...; here too [at the Exchequer] some preside, others assist and nobody is free to overstep the appointed laws. Again, just as on a chessboard battle is joined between the kings, here too the struggle is mostly between two men, namely the treasurer and the sheriff....

The battle on the chessboard could, it seems, sometimes continue for too long. Impatience with the length of the game led to initiatives to speed it up. Writing at the end of the twelfth century, Gerald of Wales describes players using fewer pieces in order to bring the game to a hastier conclusion. A chapter in his *Gemma Ecclesiastica* (*The Jewel of the Church*) on the abuse of logic draws a comparison between the ancient and modern skills of debate and chess-play:

> The pleasant comparison was made between the excellent chessplayers of ancient times who played with all the pieces and those of today who play with only a partial number of pieces ... but these days such long competitions are omitted as being too long and tedious

and they have turned to games with only some of the pieces because they consider them less tedious and more expeditious.

When Gerald speaks of the 'ancients', he is referring to the Classical past. In this he is typical of the medieval theorists who believed that chess had been invented during the siege of Troy (see p. 43). Interestingly he seems to regard the game as having some element of virtue. Lingering doubts about its moral standing did remain, however. The scientific writer Alexander Nequam's philosophical work *De Naturis Rerum* (*On the Nature of Things*), which dates to about 1200–04, describes a game of chess in some detail but concludes by condemning it as a frivolous activity. Alexander's reservations might have been fuelled by the traditional associations made between chess and gambling. Indeed, the most controversial attempt to speed up the game was the introduction of dice to determine moves, and this could have done little to dispel fears about its moral value. It is not entirely certain when the practice of using dice was first introduced. The debate between Peter Damian and the bishop of Florence in 1061–2 (see p. 48) is ambiguous enough in the vocabulary it uses to give the impression that dice might have been used in Italy even at this early date, when chess was still a relative novelty. The distinction between chess as a game of skill, as opposed to games of dice which rely on chance, was an important one and one that in the end secured the acceptance of chess as a superior game.

There is little evidence about how well the game was played in the twelfth century, but the general indication is that the standards of play were not high. In the thirteenth century a series of manuscripts emerge exploring strategies and solutions to chess problems, but all of them rely heavily on their Islamic predecessors and show little originality of thought. However, a solution to the slowness of the game was offered in the thirteenth century, when pawns were increasingly given their modern privilege of advancing two squares instead of one for their initial move; likewise kings and queens were given the ability to leap several squares

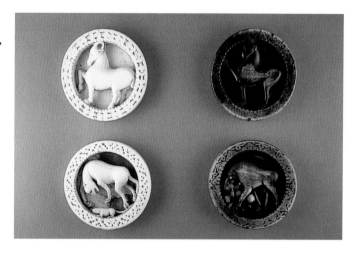

on occasion, to engage them in the game more quickly. Still, as late as 1283 the lavishly illustrated *Libro del Ajedrez* (*Book of Chess*) produced for Alfonso X of Spain recommends using dice to 'reduce the weariness which players experience from the long duration of the game when played right through'.

Tables

Dice may have been used occasionally in chess, but they were permanent features in tables. Tables was a board game known from Roman times, but it enjoyed particular prestige and popularity in the period from about 1050 to 1200. This rise in status and enthusiasm can be seen from the very high quality of the materials and the carvings that survive, along with projected estimates of how many individual tablemen must have originally existed. Bone, walrus ivory and elephant ivory were most commonly used to make the gaming pieces. The expense of the material meant that tablemen in ivory were generally elaborately carved in high relief with complex scenes which frequently featured fabulous beasts, astrological symbols or stories drawn from Classical mythology (fig. 25).

The game, as it seems to have been played in the Romanesque period, resembled modern backgammon. The tablemen found on the Isle of Lewis are unusually plain

26 Six tablemen from the group of fourteen (BM 146–59) found on the Isle of Lewis.

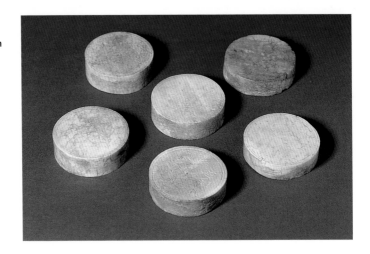

(see BM 146–59: fig. 26). A number of them have lightly incised circles, perhaps two or three made with a compass, just inside the border. They may have been scored in this way as a preliminary to being carved later, and they could therefore represent a trade in blanks. It is difficult to establish the reasons for their lack of decoration when there are so few pieces surviving: only fourteen exist out of at least thirty (the minimum number of pieces for a single game). Could it be that any completed, carved counters from the hoard were disposed of separately when they were found? Yet even without the degree of carving that normally characterizes walrus-ivory tablemen of the period, the Lewis tablemen are quite consistent with the other pieces from the hoard as high-quality merchandise destined for a deluxe market.

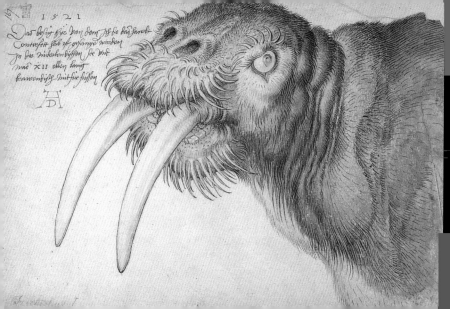

Chapter Four
The world of the walrus: raw materials, markets and skills

Paulus Orosius was a fifth-century Spanish churchman who wrote a history of civilization up to the fall of the Roman Empire. It was called *Seven Books of History against the Pagans*, and by the ninth century it was a classic text. Alfred the Great commissioned its translation into Old English in about 890. In this version, events were updated and the geographical spread was widened to include areas north of the Alps. The extended narrative includes the travels of a Norwegian called Ottar, who went on expedition to the White Sea, collecting valuable walrus tusks and skins. He visited the court of King Alfred, offering him a present of tusks:

> His main reason for going there, apart from exploring the land, was for the walruses, because they have very fine ivory in their tusks – they brought some of these tusks to the king – and their hide is very good for ship-ropes.

The trade in the tusks of the walrus, often termed 'walrus ivory' or 'morse ivory', was brisk and profitable from the mid-ninth to the thirteenth centuries. The walrus (fig. 27) was an elusive source of wealth, frequenting only the most inaccessible regions of Greenland and the far north of Norway. Its swiftness and grace in the water meant that it could only be effectively hunted on land or ice where it was slower, heavy and more vulnerable. The Norwegians were skilled in hunting in these conditions and, after their settlement of Greenland in the eleventh century, they started to export large numbers of tusks throughout Europe and beyond. This high level of trade was undoubtedly also determined by the corresponding drop in the availability of elephant ivory, for reasons still unknown.

The walrus tusks were marketed through the ports of Scandinavia (principally Norway) to destinations in Western Europe, and, via the Volga, to areas of Russia and

the Middle East. The most important points of arrival for the walrus tusks in Norway during the twelfth century were Trondheim and Bergen. The extensive trade links with the Islamic world exploited by Scandinavia from the ninth and tenth centuries are often cited as the type of exchange that might have led to the transmission of chess to Northern Europe. However, the absence of any archaeological or documentary evidence makes it unlikely. The very nature of chess implies a period of learning less suited to the rapid transactions of trade than to the social contacts formed over time in cross-cultural centres, such as the south of Italy and Spain. It would seem that the Scandinavians were among the last to receive chess along this route from south to north. What is remarkable is just how advanced the Lewis chessmen are, considering that chess was a recent arrival in Scandinavia. Their level of sophistication may be connected to the artistic innovations practised in the walrus-ivory workshops responsible for producing them, but it was most certainly prompted by the aristocratic markets that provided a demand for them.

Archaeological finds have identified workshops for the production of walrus-ivory goods at Trondheim and, further afield, at Roskilde (Denmark), Canterbury (England) and Cologne (Germany), making it clear that the tusks were often exported uncarved. They could be worked into a wide variety of items such as caskets, plaques, crozier heads, buckles and, of course, gaming pieces.

The Lewis chessmen and their associated finds are almost certainly the products of one of these centres of walrus-ivory carving. Trondheim is the most likely candidate, and the stylistic evidence already presented (p. 35) supports this suggestion. They were probably buried for safe-keeping – and subsequently never recovered – by a merchant travelling the established route between Scandinavia and Ireland, via the western seaboard of Scotland. The find of a late-twelfth-century chess queen in a bog in County Meath, Ireland, some time before 1817, points to a trade in this kind of luxury commodity along just such a route. The queen, now in the National Museum of Ireland, resembles the Lewis queens in that she is seated

on a throne and bears her head in her hand. The quality of carving, however, is inferior and she has been given an unusual lead core with an iron spike. The chess king mentioned by Madden as having been discovered at Dunstaffnage Castle on the coast of Argyll, opposite the Isle of Mull, reinforces the impression of this route. The potential markets for the sale of chess sets in this area were provided by the court of Dublin or the local aristocracy of the Outer Hebrides.

The relationship between Dublin, the Western Isles and Scandinavia, particularly Norway, was intermittently close and occasionally bloody. The period in which the Lewis chessmen were carved saw instances of significant activity. Norway exerted nominal control over the islands from 1098 in a way that, although fragile, still functioned. In 1153 the new archbishopric of Nidaros–Trondheim was created and the diocese of Man and the Isles came under its control. On two occasions the Norwegian kings offered support to the local ruler, Godfrey of Man: the first time in 1153 against aggression from Ireland, and the second in 1158 when Godfrey sought refuge from the forces of Somerled of Argyll. This political influence was certainly reflected in transactions of trade. When Godfrey of Man died in 1187, he left three sons to govern his territories: Ragnvald, Olaf and Ivar. Olaf received the Isle of Lewis, while other parts of the Isles not under Godfrey's control formed petty kingdoms for the descendants of Somerled.

There is a frustrating lack of detail about how the kingdom of Man functioned in terms of material wealth and culture. Nevertheless it is apparent that a merchant trading in objects of aristocratic appeal would undoubtedly have found an audience in the Isles and, after 1187, was likely to come into contact with at least three separate noble households. The market in walrus-ivory products, however, was about to lose its monopoly.

The vast majority of surviving objects made from walrus ivory dates from the eleventh to the thirteenth centuries. At this point the dormant trade in elephant ivory was resumed, and the affect on the traffic of walrus ivory was disastrous. Although it was probably not the only reason,

28 A walrus tusk with facsimiles of the Lewis chessmen, illustrating how the ivory was cut up to produce pieces of different size.

the fall in demand must have influenced Norway's decision to abandon its settlement of Greenland in the fourteenth century. The exceptional qualities of the walrus tusk had made it the only suitable substitute for elephant ivory over a sustained period. Other materials that were available included horn, teeth and bone, but only the walrus tusk could achieve the glossy, creamy texture that had formerly been supplied by elephant ivory.

While not as large as those produced in the elephant, the tusk of the male walrus can reach a metre in length. Those of the female walrus are smaller but have the advantage of being less curved. The carver had to consider the element of curvature in the design of his pieces and the way in which he cut up the tusk (see p. 37). Figure 28 shows replicas of some of the Lewis chessmen arranged alongside a walrus tusk to illustrate how it would have been used to create pieces of different size. The second major challenge the carver faced was to avoid the unsightly, secondary dentine in the pulp cavity of the tusk which is often formed perilously close to the surface. Occasionally this highly porous material is visible on the Lewis chessmen, either on the exterior of the piece or where a break has revealed the core (fig. 29).

The difficulty the artist encountered in making the chessmen is demonstrated by a break and repair contemporary with the carving of one of the queens (NMS 22). The left-hand side of her throne has been pinned back in place to conceal the damage. The carver, however, was usually careful to avoid areas of weakness in the execution of the chessmen. All the pieces are beautifully compact and solid, with low centres of gravity, which makes them perfect to handle and difficult to knock over accidentally during a game. The extent of any casual damage was restricted by the carver's awareness of areas of vulnerability. All points of projection are contained within the frame of each piece. Croziers, shields, swords and spears are held close to the body and do not protrude. The legs of the ponies form part of a solid base usually obscured by drapery. The rather squat anatomies of the figures with their over-large heads are partly a product

29 The break between the horse's legs of this knight (BM 111) reveals the porous dentine that fills the pulp cavity of the walrus tusk.

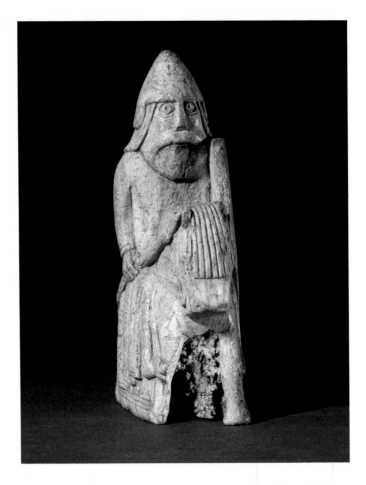

29 The break between the horse's legs of this knight (BM 111) reveals the porous dentine that fills the pulp cavity of the walrus tusk.

of the absence of necks. Although carving a neck would have given greater naturalism and grace, it would also have upset the considerations of balance and breakability: the necks of carved figures offer a notorious point of weakness.

No chessboards survive from the twelfth century. Literary references from a later period reveal that they were displayed, even when not in use, as an indication of status. The heroes of Romance were occasionally given a chessboard made of solid gold which could rapidly be transformed into a weapon. The find in 1983 of a late eleventh- or early twelfth-century gaming board and a complete set of tablemen, excavated from a rubbish pit in

Gloucester, gives us some indication of how a contemporary chessboard would have been made. Differently coloured bone plates were set into a wooden base and fixed with metal rivets. This made for a very weighty construction, particularly since medieval chessboards were undoubtedly much more substantial than their modern-day counterparts. The largest of the Lewis chesspieces would require a board to be at least 82 cm square.

When Sir Frederic Madden first examined the chessmen for his publication in *Archaeologia* of 1832, he carefully noted that a number of them had been stained red. In his descriptions of the queens he recorded that one (BM 86) 'is of the *red* set, and still preserves the colour very deeply'. He itemized those that had been stained as king (BM 80), queen (BM 86), bishops (BM 92, 93, 95 and 100), knight (BM 102) and warder (BM 125), along with a number of unspecified pawns. For the purposes of Neil Stratford's publication on the Lewis Chessmen in 1997 (see Further Reading), scientists at the British Museum inspected the pieces with a view to identifying the pigments used. In the final event no definite evidence for staining was found. We know, however, that pigments were used on walrus ivory, and the late tenth-century Einsiedeln verses discussed earlier (p. 47) describe a red-and-white chequered board for use in the game of chess, confirming that this colour combination would be appropriate. So Madden's comments make sense historically and it may simply be that the pigments have subsequently faded beyond our powers of detection. Theophilus, writing in the first half of the twelfth century, cites madder as a means of staining bone red. Madder is a herbaceous plant (*Rubia tinctorum*), the root of which was used to create a red dye.

A simultaneous scientific examination, conducted with the National Museum of Scotland, discovered that although almost all of the pieces were carved from walrus tusks, some may have been made from whales' teeth. Microscopic observation identified four warders (BM 119 and 121; NMS 28 and 29) and two pawns (BM 126 and 133) that revealed the compact cellular structure characteristic of whales' teeth. Whale-hunting was more perilous than

hunting walrus, but it was practised in the same region, off the coasts of northern Norway and Greenland.

Neither walrus ivory nor whales' teeth are preserved well in the ground. In addition, the climate of the Isle of Lewis is not necessarily kind. Yet the Lewis chessmen survived, and in large numbers. The fact that their condition is variable is probably an indication that some were more exposed to their environment than others. This would support the theory that they were concealed in a protective chamber which was disturbed at some point close to the act of discovery. It seems highly unlikely that they were ever completely submerged in water. The tiny channels that have pitted the surfaces of the pieces appear to be a result of the burrowing action of insects which live in the sand. For at least part of their subterranean life they may have been contained within a wooden box, the fabric of which would not resist well to being buried.

Unique survivals, the Lewis chessmen provide us with valuable information about the history of chess in Europe and testify to the growing power of bishops in the society of the time. No other visual record survives that documents so perfectly the full range and variety of arms and armour used in twelfth-century combat, and no other volume of finds expresses so vividly the production of luxury walrus-ivory goods for a non-religious market. It is a poignant fact that many other such chess sets probably existed and have since perished. It is sad also to think of the fate of the merchant who concealed his precious cargo in a crisis and was fated never to return, or who, once returning, was thwarted in his attempt to find his hoard by the shifting sands of Uig Bay.

Further reading

Although not easily available, in many ways the most authoritative account and most extensive examination of the Lewis finds is probably offered by Sir Frederic Madden's article, 'Historical remarks on the introduction of the game of chess into Europe and of the ancient chessmen discovered in the Isle of Lewis', in *Archaeologia* XXIV (1832), pp. 203–91. Likewise the global history of chess was more than adequately covered by H.J.R. Murray in his *A History of Chess* (Oxford 1913). These two early publications are difficult to fault and require revision only in the slightest areas. Any subsequent work is very dependent on what they have to offer. This current publication is also heavily indebted to Neil Stratford's *The Lewis Chessmen and the enigma of the hoard* (London, 1997), which cites valuable documentary and scientific findings. Other titles that may be of interest are:

Armit, I., *The Archaeology of Skye and the Western Isles* (Edinburgh, 1996).

Bagge, S., *Society and Politics in Snorri Sturluson's Heimskringla* (Los Angeles, 1991).

Blindheim, M., *Norwegian Art Abroad* (Oslo, 1972).

Dalton, O.M., *Catalogue of the Ivory Carvings of the Christian Era in the British Museum* (London, 1909).

Eales, R., *Chess: The History of a Game* (London, 1985).

Finkel, I. *The Lewis Chessmen and what happened to them* (London, 1995).

MacDonald, R.A., *The Kingdom of the Isles: Scotland's Western Seaboard c. 1100–1336* (East Lothian, 1997).

MacGregor, A., *Bone, Antler, Ivory and Horn: The Technology of Skeletal Materials since the Roman Period* (London/Sydney, 1985).

Pastoreau, M., *L'Echequier de Charlemagne* (Paris, 1990).

Roesdahl, E., 'Walrus ivory and other northern luxuries: their importance for Norse voyages and settlements in Greenland and America' in S. Lewis-Simpson, *Vinland Revisited: the Norse World at the Turn of the First Millennium* (Newfoundland, 2004).

Taylor, M., *The Lewis Chessmen* (London, 1978).

Yalom, M., *Birth of the Chess Queen* (London, 2004).